Ruins of the Palace of Emperor Diocletian

The Ancient Roman Palace at Spalatro in Dalmatia – Modern-day Split, Croatia – Illustrated in the 1760s

By Robert Adam

Architect to King George III of England

PANTIANOS
CLASSICS

Published by Pantianos Classics

ISBN-13: 978-1-78987-391-7

First published in 1764

Contents

To the King

I Beg Leave to lay before your Majesty the Ruins of Spalatro, once the favorite Residence of a great Emperor, who, by his Munificence and Example, revived the Study of Architecture, and excited the Matters of that Art to emulate in their Works the Elegance and Purity of a better Age.

All the Arts flourish under Princes who are endowed with Genius, as well as possessed of Power. Architecture in a particular Manner depends upon the Patronage of the Great, as they alone are able to execute what the Artist plans. Your Majesty's early Application to the Study of this Art, the extensive Knowledge you have acquired of its Principles, encourages every Lover of his Profession to hope that he shall find in George the Third, not only a powerful Patron, but a skilful Judge.

At this happy Period, when Great Britain enjoys in Peace the Reputation and Power he has acquired by Arms, Your Majesty's singular Attention to the Arts of Elegance, promises an Age of Perfection that will complete the Glories of your Reign, and fix an era no less remarkable than that of Pericles, Augustus, or the Medicis.

I am,

May it please Your Majesty,

Your Majesty's

Most Dutiful Servant, and Faithful Subject,

ROBERT ADAM

Introduction

THE buildings of the Ancients are in Architecture, what the works of Nature are with respect to the other Arts; they serve as models which we should imitate; and as standards by which we ought to judge: for this reason, they who aim at eminence, either in the knowledge or in practice of Architecture, find it necessary to view with their own eyes the works of the Ancients which remain, that they may catch from them those ideas of grandeur and beauty, which nothing, perhaps, but such an observation can suggest.

Scarce any monuments now remain of Grecian or of Roman magnificence but public buildings. Temples, amphitheatres, and baths, are the only works which had grandeur and solidity enough to resist the injuries of time, and to defy the violence of barbarians: the private but splendid edifices in which the citizens of Athens and of Rome resided, have all perished; few vestiges remain of those innumerable villas with which Italy was crowded, though in erecting and adorning them the Romans lavished the wealth and spoils of the world. Some accidental allusions in the ancient poets, some occasional descriptions in their historians, convey such ideas of the magnificence, both of their houses in town and of their villas, as astonish an artist of the present age. The more accurate accounts of these buildings, which we find in Vitruvius and Pliny, confirm this idea, and convince us, that the most admired efforts of modern Architecture, are far inferior to these superb works, either in grandeur or in elegance. There is not any misfortune which an Architect is more apt to regret than the destruction of these buildings, nor could anything more sensibly gratify his curiosity, or improve his taste, than to have an opportunity of viewing the private edifices of the Ancients, and of collecting, from his own observation, such ideas concerning the disposition, the form, the ornaments, and uses of the several apartments, as no description can supply.

This thought often occurred to me during my residence in Italy; nor could I help considering my knowledge of Architecture as imperfect, unless I should be able to add the observation of a private

edifice of the Ancients to my study of their public works. This led me to form the scheme of visiting the Ruins of the Emperor Diocletian's Palace at Spalatro, in Dalmatia; that favorite building, in which, after resigning the empire, he chose to reside. I knew, from the accounts of former travellers, that the remains of this palace, though tolerably entire, had never been observed with any accuracy, or drawn with any taste; I was no stranger to the passion of that prince for Architecture, which prompted him to erect many grand and expensive structures at Rome, Nicomedia, Milan, Palmyra, and other places in his dominions; I had viewed his public baths at Rome, one of the noblest, as well as most entire, of all the ancient buildings, with no less admiration than care; I was convinced, notwithstanding the visible decline of Architecture, as well as of the other arts, before the reign of Diocletian, [1] that his munificence had revived a taste in Architecture superior to that of his own times, and had formed artists capable of imitating, with no inconsiderable success, the style and manner of a purer age. The names and history of those great matters are now unknown, but their works which remain, merit the highest applause; and the extent and fertility of their genius, seem to have equaled the magnificence of the monarch by whom they were employed.

Induced by all these circumstances, I undertook my voyage to Dalmatia with the most sanguine hopes, and flattered myself that it would be attended not only with instruction to myself, but might produce entertainment to the public.

Having prevailed on Mr. Clerisseau, a French artist, from whose taste and knowledge of antiquities I was certain of receiving great assistance in the execution of my scheme, to accompany me in this expedition, and having engaged two draughtsmen, of whose skill and accuracy I had long experience, we set fail from Venice on the 11th of July, 1757, and on the 22d of that month arrived at Spalatro.

This city, though of no great extent, is so happily situated, that it appears, when viewed from the sea, not only picturesque but magnificent. As we entered a grand bay, and failed slowly towards the harbour, the Marine Wall, and long Arcades of the Palace, one of the ancient Temples, and other parts of that building which was the object of our voyage, prevented themselves to our and nattered me,

from this first prospest, that my labor in visiting it would be amply rewarded.

To these soothing expectations of the pleasure of my talk, the certain knowledge of its difficulty soon succeeded. The inhabitants of Spal.ro have destroyed some parts of the palace, in order to procure materials for building and to this the town owes its name, which is evidently a corruption of Palatium. In other places houses are built upon the old foundations, and modern works are so intermingled with the ancient, as to be scarcely distinguishable: assiduity, however, and repeated observation, enabled me to surmount these difficulties. Attention to such parts of the palace as were entire, conducted me with certainty to the knowledge of those which were more ruinous; and I was proceeding in my work with all the success I could have expected, when I was interrupted by an unforeseen accident.

The Venetian governor of Spalatro, unaccustomed to such visits of curiosity from strangers, began to conceive unfavorable sentiments of my intentions, and to suspect that under pretence of taking views and plans of the Palace, I was really employed in surveying the state of the fortifications. An order from the Senate to allow me to carry on my operations, the promise of which I had procured at Venice, had not yet arrived; and the governor sent an officer commanding me to desist. By good fortune General Graeme, commander in chief of the Venetian forces, happened at that time to be at Spalatro on the service of the State. He interposed in my behalf, with the humanity and seal natural to a polite man, and to a lover of the Arts, and being warmly seconded by Count Antonio Marcovich, a native of that country, and an officer of rank in the Venetian service, who has applied himself with great success to the study of Antiquities, they prevailed on the governor to withdraw his prohibition, though, by way of precaution, he appointed an officer constantly to attend me. The fear of a second interruption added to my industry, and, by unwearied application during five weeks, we completed, with an accuracy that afforded me great satisfaction, those parts of our work which it was necessary to execute on the spot.

Encouraged by the favorable reception which has been given of late to works of this kind, particularly to the Ruins of Palmyra and Balbec, I now present the fruits of my labor to the public. I am far

from comparing my undertaking with that of Messieurs Dawkins, Bouverie, and Wood, one of the most splendid and liberal that was ever attempted by private persons. I was not, like these gentlemen, obliged to traverse deserts, or to expose myself to the insults of barbarians; nor can the remains of a single Palace vie with those surprising and almost unknown monuments of sequestered grandeur which they have brought to light; but at a time when the admiration of the Grecian and Roman Architecture has risen to such a height in Britain, as to banish in a great measure all fantastic and frivolous tastes, and to make it necessary for every Architect to study and to imitate the ancient manner, I flatter myself that this work, executed at considerable expense, the effect of great labor and perseverance, and which contains the only full and accurate Designs that have hitherto been published of any private Edifice of the Ancients, will be received with indulgence, and may, perhaps, be esteemed an acquisition of some importance.

[1] Diocletian began his reign An. Dom. 284. He resigned the empire in the year 304, and died in the year 313; having spent the last nine years of his life at Spalatro.

A Description of the General Plan of Diocletian's Palace

as Restored

Explaining

The Manner of disposing the Apartments in the Houses of the Ancients

THE Palace of Diocletian at Spalatro possessed all those advantages of situation, to which the Ancients were most attentive, and which they reckoned essential to every agreeable villa. The soil of that part of Illyricum was dry and fertile, thought now considerable tracts of land lie uncultivated. The air is pure and wholesome; and though extremely hot during the summer months, this country seldom feels shoes sultry and noxious winds to which the coast of Istria, and some parts of Italy, are exposed. By the care of the architect in observing an excellent precept of Vitruvius [1], every inconvenience arising from the winds is avoided as far as possible; the principal streets or apertures of the villa being so disposed, as not to lie open to the impression of any of the winds which blow most frequently in this climate. The views from the palace are no less beautiful, than the soil and the climate were inviting. Towards the West lies the fertile shore that stretches along the Adriatic, in which a number of small islands are scattered in such a manner, as to give this part of the sea the appearance of a great lake. On the North West lies the bay which led towards the ancient city of Salona, and the country beyond it appearing in fight, forms a proper contrast to that more extensive prospect of water which the Adriatic presents both to the South and to the East. Towards the North the view is terminated by high and irregular mountains, situated at a proper distance, and in many places covered with villages, woods, and vineyards.

From this description, as well as from the views which I have published, (Plates 3rd and 4th) it is evident that no province in this wide-extended empire, could have afforded Diocletian a more ele-

gant place of retirement; and the beauty of the situation, no less than the circumstance of its being his native country, seems to have determined him to fix his residence there.

The only thing wanting at Spalatro was good water; but this defect was supplied by an aqueduct from Salona, (Plate 61) several arches of which remain at present, and the conduit that formerly conveyed the water is still visible.

The palace itself was a work so great, that the Emperor Constantinus Porphyrogenitus, who had seen the most splendid buildings of the Ancients [2], affirms that no plan or description can convey a perfect idea of its magnificence. The vast extent of ground which it occupied is surprising at first fight; the dimensions of one side of the quadrangle, including the towers, being no less than 698 feet, and of the other 592 feet, making the superficial content 413216 feet, being nearly nine and an half English acres. But when we confider that it contained proper apartments not only for the Emperor himself, and for the numerous retinue of officers who attended his court, but likewise edifices and open spaces for exercises of different kinds; that it was capable of lodging a pretorian cohort, and that two temples were erected within its precincts, we will not conclude the area to have been too large for such a variety of buildings.

The present state of this great structure may be more perfectly conceived, by considering the Plan of it, (Plate 5) than by any description whatever. The curiosity of the reader, however, will not be satisfied with viewing this building in its present ruinous condition, but must naturally desire to form some idea of what was its plan and disposition in its more perfect state. By good fortune its remains are, in many places, so entire, as to be able to fix, with the utmost certainty, the form and dimensions of the principal apartments. The knowledge of these leads to the discovery of the corresponding parts; and the descriptions given us by Pliny [3] and Vitruvius [4] of the Roman villas, enable us to assign to each apartment its proper name, and to discover its use. The manners and domestic life of the Ancients differed so widely from ours, that their ideas, with regard to what was necessary or ornamental in a dwelling house must likewise have been extremely different.

The whole building was of a quadrangular form, (Plate 6) and was divided by two large streets, leading to the different gates, and crossing each other at right angles.

The principal street which we enter from the North, is 36 feet 3 inches in breadth: its length, from the inside of the gate to the place where it intersects the street which runs from East to West, is 238 feet 5½ inches; the breadth of the other street is the same, and it extends 424 feet 6 inches. Both of them are bounded on each side by Arcades of 13 feet wide, many of which are still entire. The first of these streets leads directly to the Peristylium (A), which was the name the Ancients gave to the area or court before their villas.

From the Peristylium we ascend by a flight of steps into the Porticus (B), which is of the Corinthian Order. From this there were doors to two winding stairs, which led to the ground story, in order that the slaves might have access thither, without passing through any of the apartments.

From the Porticus we enter the Vestibulum (C) which was commonly of a circular form [5]; and in this Palace it seems to have been lighted from the roof. It was a sacred place, consecrated to the Gods, particularly to Vesta [6], (from whom it derived its name) to the Penates and Lares, and was adorned with niches and statues. Next to the Vestibulum is the Atrium (D), a spacious apartment, which the Ancients considered as essential to every great house. As the Vestibulum was sacred to the Gods, the Atrium was consecrated to their Ancestors, and adorned with their images, their arms, their trophies, and other ensigns of their military and civil honours. [7] By this manner of distributing these apartments, the Ancients seem to have had it in view to express, first of all reverence for the Gods, who had the inspection of domestic life; and in the next place, to testify their respect for those Ancestors to whose virtues they were indebted for their grandeur. On each side of the door into the Atrium, lie two small rooms, one of which may have been the Cella Ostiarii (E), or Porter's Lodge, which Vitruvius tells us was common in houses of the Greeks, and was placed on one side of that passage by them called Thyrorion: the other was probably what the Ancients named a Tablinum (F), which Pliny mentions as a repository for the archives and records of the family, containing the history of the illustrious actions of their ancestors.

From the Atrium we proceed to the Crypto Porticus (G), a place of vast extent, intended for walking, and other exercises, which the Ancients reckoned of such importance, that the securing proper conveniences for them, was a chief object in all their buildings. This

Crypto Porticus, like our modern galleries, was probably adorned with statues, pictures, and bas reliefs, and in this Palace serves likewise for giving access to several apartments, without passing through, the rooms of parade, which were also defended by it, from the excessive heat of the south fun; a circumstance of so much conference in hot climates, that we often find Vitruvius and Pliny attending to it with particular care.

If from the center of the Crypto Porticus, we look back to those parts of the Palace which we have already passed through, we may observe a striking instance of that gradation from less to greater, of which some connoisseurs are to lend and which they distinguish by the name of a Climax in Architecture. The Vestibulum is larger and more lofty than the Porticus. The Atrium much exceeds the grandeur of the Vestibulum; and the Crypto Porticus may well be the last step in such a Climax, since it extended no less than 517 feet. We may likewise observe a remarkable diversity of form, as well as of dimensions, in these apartments which we have already viewed, and the same thing is conspicuous in other parts of the Palace. This was a circumstance to which the Ancients were extremely attentive, and it seems to have had an happy effect, as it introduced into their buildings a variety, which, if it doth not constitute Beauty, at least greatly heightens it. Whereas Modern Architects, by paying too little regard to the example of the Ancients in this point, are apt to fatigue us with a dull succession of similar apartments.

Next to the Alae of the Atrium (H) are two passages (I), which by the Romans were called Andrones, and by the Greeks Masaulae, from the situation between halls. There is access from them to several great rooms; they were lighted from the roof, and seem to have been contrived in order to prevent the noise of the Ancients, or Slaves in waiting in the Atrium, from reaching the adjacent apartments; and for that reason these apartments have not their entry immediately from the Atrium.

The first of these grand rooms is the Basilica (K), which Vitruvius mentions as common in all great houses, and directs that it should be spacious and magnificent in proportion to the dignity of the proprietor. Diocletian's Architect has been careful to observe this precept; the Basilica here being such as suited the magnificence of an Emperor. This apartment was allotted for dramatic performances, recitals, music, and such like entertainments, and was lighted

from the roof. On the other side of the Atrium, and corresponding to the Basilica, is the Egyptian Hall (L), which, according to Vitruvius, was nearly of the same form with the Basilica, and seems to have been lighted much in the same manner.

Adjoining to this is the Corinthian Hall (M), with regard to which the Architect has observed a rule of Vitruvius, by making the length of the room twice its breadth; and it is highly probable that he has likewise followed his direction, to light it from the North over the roofs of the Exedrae and Tetrastyle Halls, in the same manner as we find it often practiced in the Baths at Rome.

Corresponding to the Corinthian Hall, and opposite to it, is the Cyzicene Hall (N), which in every particular resembles the former. These three halls, together with the Tetrastyles, or rooms of four columns (O), Vitruvius calls by the common name of Oeci. They were apartments for eating, and were generally of such a size, as to hold two Triclinia, or tables, with three beds each.

As the Oeci were employed in the same manner with our modern dining rooms, the Exedrae (P) served for the same uses with our withdrawing rooms. They were intended chiefly for conversation. Cicero calls them Cellae ad Colloquendum: They were placed near to the eating rooms, and are here lighted from the North.

Next to these we find the different apartments destined for bathing; a practice which the Ancients considered as essential to health; and with regard to all the apparatus necessary for that purpose, they displayed not only great elegance, but the utmost luxury. Here we first enter an Apodyterium (Q), which was a room for undressing, and sometimes contained a Callida Piscina, or Lukewarm Bath (R), so large as to allow of swimming about in it. Next to this is the Cella Frigidaria (S), in which there was a Babtisterium, or Cold Bath. Adjoining to this is the Unctuarium (T), or Repository for Unguents, with which the Ancients anointed themselves before their exercises. From this we go into the Cella Tepedaria (U), or Cella Media, so named from its middle degree of heat, and because it was a necessary preparation for the Laconicum, or Cella Caldaria (V), which was a bagnio for sweating in. All these different rooms in the Bathing Apartment were lighted from the roof.

On the other side of the Cella Media was a Sphaeristerium (W), a room allotted for the different exercises of the ball: this too must have been lighted from the roof. On the other side was the Emper-

or's Cubiculum Dormitorium, or Bed Chamber (X), which lay extremely convenient for the Bathing Apartment, and seems to have been particularly contrived for excluding light and noise. Pliny mentions an invention of the same kind in a bed chamber at his villa of Laurentinum.

Adjoining to it, and towards the Crypto Porticus, was what I take to have been a private Caenatio (Y), or Supping Room. This enjoyed the benefit of the setting sun, which for winter eating rooms Vitruvius recommends as requisite. On the other side of the Cubiculum Dormitorium lie three rooms, two of which, upon the authority of Pliny, I name Procaetones, or Antichambers (Z), and the other Cella Liberti (a), or Freedmans Room.

Beyond the exterior Procaetori, and adjoining to the Arcade, are a number of vaults, which were probably employed as Cellae Servorum (b), or Cells for the Slaves; though originally, and during the time that Diocletian held the empire, they might be used for lodging the Pretorian Soldiers.

In those Cellae which lie next to the walls of the Bathing Apartments, were the Hypocauston (c); the Propnygeon (d); the Milliarium (e); and Cellae Lignariae; Lignariae (f); which were the names that the Ancients gave to the places and machinery employed for heating their baths, and other apartments.

For it is observable, that during all my researches among the ruins of this fabric, I could not perceive the smallest vestige of a fire place. Though this was a circumstance to which I attended with particular care, [8] fire places however the Ancients undoubtedly had, as Vitruvius mentions them, and directs the cornices of those rooms in which they were used, to be purae or unenriched, that the dirtiness contracted by the smoke might be the more easily wiped off. There are many passages in the Roman authors [9] which prove that they used chimneys in their different apartments; and Palladio [10] and Barbaro assure us that, in their time, there were still to be seen the remains of fire places, with vents for carrying off the smoke, in three different parts of Italy: but at the same time it is no less evident, that the most common method of warming their rooms, especially in the houses of persons of distinction, was by conveying hot air to them through pipes fixed in the walls. [11] In Pliny's description of his summer villa at Tusculum, he mentions a large Cubiculum, which in hot weather was sufficiently warmed by

the fun, and when the weather was cloudy, it received a supply of warm air from the Hypocauston: And in his letter concerning his winter villa at Laurentinum, he expressly takes notice of his bed-chamber being warmed by hot air, which, without doubt, was also conveyed from the Hypocauston. In the days of Vitruvius, chimneys seem to have been more common, but it is probable that as the passion for pomp, and the love of expense in building increased, the use of funnels in conveying and distributing hot air, might be gradually introduced, and the Romans might come to prefer this method, which had all the advantages of fire, without being subject to any of its inconveniencies. The use of hot baths, which became more frequent after the age of Vitruvius, contributed not a little to spread the fashion of warming the different apartments by means of flues.

The Baths, the Dormitorium, the Spheristorium, and other apartments which I have just now described, lie all in the West end of the Palace. There are not now any remains of the Eastern part of the Imperial apartments beyond the Egyptian and Corinthian Halls. But as there is an exact uniformity in those rooms on each side of the Atrium, so far as they remain, I thought it most eligible not to indulge my fancy in forming any new conjecture, but simply to repeat the same distribution on this as on the other side; especially as a separate bathing apartment for the women, seems necessary to compleat the conveniency and elegance of this building.

The Pinacotheca, or Room for Pictures, and the Bibliotheca, or Library, are apartments which Vitruvius mentions as common in all the great houses of the Romans: It would therefore surprise the reader, should he find no such rooms in the Palace of an Emperor, who was so remarkable for his love of the Fine Arts. But if we consider that noble Porticus or Gallery, which stretches along three sides of this building above the Cellae Servorum and Arcades, extending no less than 1212 feet in length, and 31 feet in breadth, it is evident that sufficient space was left for apartments consecrated to those elegant Arts, of which Diocletian was so great an admirer.

Towards the East (as we learn from Vitruvius) was the proper situation for the Bibliotheca; towards the North was the exposure most approved of for Pictures; and the West side may have been reserved for an Horreum, a room which Pliny mentions as a repository for statues, bas reliefs, and other curious productions of art.

This gallery was divided by the three gates to the palace, and by the flairs on each side of them; but I found the communication had been preferred by passages formed in the thickness of the wails over the gates, as may be seen by the general sections.

I come now to the Temples, which are placed in two areas adjoining to the palace, and are seen on each side of the Peristylium, through its rows of granite columns. Such attention to the honor and worship of the Gods, is suitable to the character which is given of Diocletian by ancient authors.

The square Temple (g), which was situated on the West of the Periftylium, was dedicated to Aesculapius. [12] If we describe it according to the terms of ancient Architecture, it was Prostylos, Tetrastylos, and its intercolumniations were something more than Systylos; that is to say, the columns are all on one principal front; there are four of them on that front, and the intercolumniations are about two and a fifth diameters. The ascent to it was by a stair of fifteen steps, an uneven number being generally used in the Temples of the Ancients, that beginning to move with the right foot, they might of course place it first upon the uppermost step, in order to enter the Temple, a form which they accounted respectful in approaching a Deity. [13] This Temple, like many other of the ancient ones, received no light but by the door. Beneath it are vaults of great strength; its roof is an arch adorned with sunk pannels of beautiful workmanship, and its walls are of a remarkable thickness. The Ancients were extremely solicitous to render their religious edifices as durable as possible, and the effects of this attention are now visible. This Temple still remains almost entire, and is at present employed by the Spalatrines as a Baptistery.

On the other side of the Peristylium stands the Octagonal Temple (h) dedicated to Jupiter (i), who was worshipped by Diocletian with peculiar veneration, and in honor of whom he assumed the surname of Jovius. This Temple is of that kind, which Vitruvius calls Perypteros, i.e. surrounded with one row of columns, having an intercolumniation or space between them and the wall. Its intercolumniations are more than Areostyles, i.e. upwards of four diameters. It is lighted by an arched window over the door, and is vaulted beneath like that of Aesculapius. The dome over it is of bricks constructed in a very singular and ingenious manner, which, together with its walls, are of such solidity as to have refitted, almost unhurt,

the injuries of so many ages; and I have even observed several of the styles upon the roof still distinctly impressed with the Roman stamp, S. P. Q. R. . It is at present the Cathedral Church of Spalatro, and is consecrated to the Virgin Mary, and St. Domnius.

This Temple is situated nearer to the Peristylium than the other; the reason of which seems to have been in order to gain space behind it for a Sacellum, [14] where sacrifices might be offered on an altar looking towards the East, which, according to Vitruvius, was a circumstance not to be dispensed with.

The common opinion at Spalatro, which has been received without examination by several travellers, is, that there were four Temples within the precincts of the Palace. That apartment which for many reasons I have considered as the Vestibulum of the Palace, has hitherto been taken for one of these Temples. Of the fourth no vestige whatever is to be found, though I searched for it with great care. Were the controversy of much importance, it might easily be shewn, that there is no good authority for supporting there were formerly four Temples; but that in all probability none ever belonged to this Palace but the two which now remain.

In the description of this edifice, no mention has been made of a Culina, or kitchen of the Cellariae, Apothecae, and other offices which must necessarily have belonged to such a building. These, without doubt, were in proportion to the other parts of so great a work, and must have been placed in the half sunk or vaulted story. Part of these vaults now remain entire, and at present are used by the merchants for warehouses. They lie all along that side of the Palace next to the sea, and under the Crypto Porticus. There is also another vault which runs from South to North, under the Atrium, Vestibulum, and Porticus, which appears to have been a common entry to all the under-ground offices. these have been partly destroyed, and partly filled up; insomuch that without great labor and expense in digging, it was not possible exactly to discover their disposition, or to form any plausible conjure concerning their different uses. I attempted, however, at different times, to dig in various quarters of the Palace, and very probably might have made some useful discoveries, had not the repeated alarms and complaints of the inhabitants prevailed upon the Governor to send me the most positive orders to desist. I was therefore obliged, though with regret, to obey, and hastened to finish what remained uncompleted

above ground, lest fresh suspicions should have prevented me from proceeding with that more essential part of my work.

All the buildings which we have hitherto surveyed, lie on the South side of that street which runs from the East to the West Gate. On the North of that street were situated two buildings (k) and (l), not much inferior in extent, nor probably in magnificence, to those we have already described: but by the injuries of time, and the depredations of the Spalatrines, these structures are reduced to a very ruinous condition; and though some walls still remain, which fix the form and dimensions of a few apartments, and show that they confided of two stories, yet we have little to guide us in judging with regard to the arrangement and disposition of the whole. I have ventured, however, to form a plan of these buildings, by observing as carefully as possible such traces of the ancient divisions as are still visible. This I lay before the reader, who must rest satisfied with conjecture, where certainty cannot be attained. I suppose one of these buildings (k) to have been a Gynaeceum, or an apartment allotted by the Ancients for the matrons and young women, and the other (l) I call the Aulicorum Aedes, or apartments for the different attendants on a court. The Jesuit Farlatus mentions such apartments as constituting part of this Palace; as also a Domus Uxoris, [15] or apartment for the Empress; which last I have already placed in the East end of the Palace, corresponding to that of the Emperor.

The Towers are the only part of the Palace of which we have not taken a view. There are sixteen in all round this building, one on each angle, and four on each side, except on that towards the Adriatic. these Towers seem to have been intended for ornament, rather than for defence; it being impossible that a structure of this kind could ever be designed for a place of strength. We learn from Pliny, that towers were no uncommon ornament even in the villas of private persons. There were two of them in his villa at Laurentinum; and in them he places not only keeping apartments, but a Caenatio, and Triclinium, a Horreum, and Apotheca. Here they might have been employed partly for the same, or perhaps for several other purposes.

Joannes Tomcus Marnovitius, an author whose words are produced by Farlatus, [16] assures us, that in one of these Towers towards the South, was the burial-place of Diocletian, and that about two centuries ago, the body of the Emperor had been discovered

there. He is even so minute as to describe the Porphyry Sarcophagus in which his remains were contained. If we may credit this authority, it appears that Diocletian chose to have his allies deposited in the same favorite spot where he fixed his residence during the latter part of his life.

[1] Vitruvius, L. I. C. 4 and 6. L. 6. C. I.

[2] Conft. Porphyrogenitus de Adminirtrando Imperii ad Romanum Filium.

[3] Plinius Junior, L. 2. Ep. 17; & L. 5. Ep. 6.

[4] Vitruvius, L. 6.

[5] Leo. Bap. Alberti, L. 9. C. 3.

[6] At Focûs a flammis, et quod fovet omnia dictus
 Qui tamen in primis aedibus ante fuit.
 Hinc quoque Veftibulum dici reor, Inde precando
 Dicimus, O Vefta quae loca prima tenes.
Ovid. L. 6. Fastor.

[7] Apud majores in Atriis, Imagines has erant quae spectarentur; non figna externorum artincium nec aera nec marmora. Plinius Senior, L. 35. C. 2. And a little lower he adds: Aliae foris et circa limina Animorum ingentium imagines erant; affixis Gentium spoliis, quae nec Emptori refringere liceret; triumphabantque etiam dominis mutatis ipsae domus: et erat haec stimulatio ingens, exprobrantibus tectis, quotidie imbellem dominûm entrare in alienam triumphum.

 The Poets often allude to this cuftom:
 - Spolia illa tuis pendentia tectis. - Virg. Aeneid. L. 4.

 Nec te decipiant veteris quinque Atria Caerae
 Tolle tuos tecum, pauper Amator Avos. - Ovid. L. 1. Amor. Elig. 8.

[8] In one of the highest walls of that building marked K, which I call the Gynecum, or apartments for matrons and young women, I discovered a chimney, which at first fight I took to be Ancient; but upon a nearer inspection, I found the construction to be undoubtedly of a later date, with a modern flue formed in the ancient wall.

[9] Dissolve frigus Ligus super foco
 Large reponens. Hor. L; I. Carmen 9.
 Nifi nos Vecina Trivici

Villa recipiffer, Lacrimoso non sine sumo
Udos cum foliis ramos urente Camino. Hor; L, I. Sat. 5.

[10] Palladio, L. 1. C. 27. Barbara's Comment on his Italian Transla-
tion of Vit. L. 6. C. 10.

[11] Seneca tells us, Epist, 90. Ter impressos Parietibus Tubus ner
quos circumfundiretur Calor, qui ima simul et summa seriret
equaliter.

[12] Petrus Nicolinus, whose Manuscript is frequently cited by Far-
latus, tells us: Tertium quoddam sanum Bafflicae, e regione objacet
ab occidente, quondam Aesculapio sactum, Sacelli forma quadrata
est, uno sornice Lapideo obtegetur mira Arte Caelato, &c. J. S. Tom.
I. p. 489. The history of Salon, by Archidiocanus, is also cited by
Farlatus to the same purpose.

[13] Vitruvius, L. 3. C. 3. Alberti, L. 1. C 13.

[14] From Farlatus we have these words of Petrus Nicolinus, relat-
ing to this Temple , Quod autem scripsit platina, id olim Cibelis
sanum Suisse, longe abest a Veritate, nemini quippe debium esse
potest, quin vetus et profana superstitio illud Jovi dedicaverit. Jovis
simulachrum quod inibi collebatur adhuc extat, Visiturque in
Mufeo gentis Capellae, inter Patricias Venetorum familias Antiquae
et Conspicuae. J. S. Tom. I. p. 489.

[15] Hic fuae Aulicis aedes, et domus Uxori; et Matronis puellisque
suum conclave, sive Gynaeceum. Illyricuna Sacrum, Tom. 2. p. 397.

[16] Illyricum Sacrum, Tom. 2. p. 414.

The Plates, and Their Explanations

with Occasional Remarks on the Style of the Architecture.

Throughout this Work, all the Geometrical Plans, Elevations, and Sections, are figured in English Feet and Inches.

The Detail of the particular Orders and other Parts of the Buildings, are figured in Modules and Minutes, with Scale of Feet and Inches annexed to each Plate.

PLATE I - FRONTISPIECE

GENERAL PLAN
of the *TOWN* and *FORTIFICATIONS* of
S P A L A T R O.
Shewing the Situation of the Ancient Palace
of the

EMPEROR DIOCLESIAN.

Also the Great Bay and Harbour. The Lazaretto,
the Mountain Margliano, the Fort of
Grippe, The Suburbs & the
Adjacent Grounds.

22

PLATE II.

General Plan of the Town and Fortifications of Spalatro, shewing the Situation of the Ancient Palace of the Emperor Diocletian; also the great Bay and Harbour, the Lazaretto; the Mountain Margliano, the Fort of Grippe, the Suburbs, and the adjacent Grounds.

A. The Great Bay.

B. The Harbour.

C. Different Courts of the Lazaretto, in which the people trading from Turkey perform Quarantine, and where the Goods are purified.

D. The Palace of Diocletian, which is shaded darker than the Modern Buildings.

E. The Plaza or Market Place of the present Town; the Houses of which are represented by single Lines, both within and without the palace.

F. Fortifications round the Town, built during the War of Candia.

G. The Fort of Grippe.

H. The Suburb called the Borga Luciaz.

I. The Suburb called the Borgi Manus.

K. The Suburb called the Borgi Pozzo Bon, or Dobri.

L. The Suburb called the Borga Grande.

M. The Mountain Margliano, upon the Summit of which the Jews have their Burying Ground.

N. A ruinous Fortification called Forte Botecelle.

N. B. At the Top of this Plate are introduced some Parts of the Ancient Buildings of the Palace in Perspective.

View of the Town of [...]

PLATE III.

View of the Town of Spalatro from the East.

26

A. The Temple of Jupiter, now the Cathedral Church.

B. A Modern Spire, built upon the Landing of the Stairs to the Temple of Jupiter, mostly composed of Fragments of Marble brought from Salona, and of Columns of Granite and other Materials, taken from the Palace. It now serves as a Steeple to the Cathedral Church.

C C. Ancient Walls of the Palace.

D D D. Modern Fortifications.

E E. The Bay of Salona, which runs up into the Country three Miles, behind the Mountain Margliano.

F. Lazaretto.

G. The Harbour.

H. Point of Land which forms the West Side of the Great Bay of Spalatro.

I. The Mountain Margliana.

K K K K. Islands in the Adriatic belonging to the Venetians.

L. The Isthmus of Trau, anciently Tragurium, three Leagues from Spalatro; from which Place the Stones were brought to build the Walls of Diocletian's Palace. These Quarries still remain open, and in them the People of Trau find Stones of the same Quality with those of which many Parts of the Palace are constructed.

View of the Town of Spilsby

PLATE IV.

View of the Town of Spalatro from the South West.

A. Temple of Jupiter.
B. Steeple of the Cathedral Church.
C. A Tower, formerly used as a Powder Magazine.
D D D. Modern Fortifications.
E. Wall of the Crypto Porticus, or Front of the Palace towards the Sea.
F F. Ancient Towers at each End of the Crypto Porticus.
G. The Lazaretto.
H. The Harbour.
II. Mills for making of Oil.
K. Part of a Monastery.

General Plan of the Palace as it now Remains

PLATE V.

General Plan of the Palace as it now remains.

Although in this Plate the Parts shaded with a dark Colour are what alone appear now above Ground, yet I have ventured to call this a Plan of the Palace as it remains; the Parts supplied in a lighter Colour being traced with the greatest Certainty, either from the Foundations, or formed by joining the Lines of the corresponding Walls.

A. The North or principal Gate, called still by its ancient Name, Porta Aurea.

B. The Street leading to the Emperor's Apartments.

C. The West Gate, called Porta Ferrea,

D. The East Gate, called Porta Aenea.

E. Street running from the East to the West Gate.

F. The Piazza, or Court of the Palace.

G. The Temple of Jupiter, now the Cathedral Church, consecrated to the Virgin Mary and St. Dominus.

H. The Temples of Aesculapius, now the Baptistery, consecrated to St. John the Baptist.

I. The Vestibule of the Palace.

K. Other Apartments of the Palace.

L. Bathing Apartments, &c.

M. Square and Octagon Towers.

N. Gallery to the South, or Crypto Porticus.

O. Vaulted Cells round the exterior Walls of the Palace.

P. A detached Building much ruined.

Q. Another detached Building.

R. Streets of Communication within the Palace.

S. Covered Arcades on each Side of the principal Streets.

T. Open Courts.

N. B. As the explanation of Plate VI. Describes very fully the Names and Uses of the different Apartments of the Palace, to avoid Repetition, I have here referred by Letters only to the principal Parts of this Plan.

General Plan of the Palace Blenheim

35

PLATE VI.

General Plan of the Palace restored.

The Description of the general Plan, explaining the Manner of disposing the Apartments in the Houses of the Ancients, refers to this Plate.

A. Peristylium, or Fore Court.

B. Porticus, or Portico.

C. Vestibulum, or Vestibule.

D. Atrium, or Great Hall.

E. Cella Ostiarii, or Porters Lodge.

F. Tablinum, or Repository for Records,

G. Crypto Porticus, or Gallery for Exercises and Walking.

H H. Alae Atrii, or Wings of the Hall.

I I. Andro07nes, aut Mefaulae, or Passages of Communication, and for preventing Noise.

K. Basilica, or Room for Theatrical and Musical Entertainments.

L. OEcos, aut Triclinium Egyptium, or Egyptian Hall.

M. OEcos, aut Triclinium Corinthium, or Corinthian Hall.

N. OEcos, aut Triclinium Cyzicenum, or Cyzicene Hall.

O. OEci, aut Triclinia Tetrastyla, or Rooms of four Columns.

P. Exedrae, or Rooms for Conversation.

Q. Apodyterium, or a Dressing and Undressing Room.

R. Calida Piscina, or Lukewarm Bath.

S. Cella Frigidaria cum Baptisterio, or Room containing a Cold Bath.

T. Unctuarium, or Repository for Unguents.

U. Cella Tepidaria, feu Cella Media, or Room of moderate Heat.

V. Laconicum feu Cella Caldaria, or a Sweating Room or Bagnio.

W. Sphaeristerium feu Coriceum, or Room for Exercise of the Ball, &c.

X. Cubiculum Dormitorium Diocietiani, or Diocletian's Bed-Chamber.

Y. Cenatio, or Supping Room.

Z. Procaetones, or Anti-Chambers.

a. Cella Liberti, or Freedmans Room.

b. Cella Servorum, or Slaves Rooms.

c. Hypocauston, or Furnace.

d. Propnygeon aut Praefurnium, or Room before the Furnace.

e. Milliarium, a Spiral Pipe of Copper for heating Water for the Hot Bath.

f. Cella Lignariae, or Vaults for Wood.

g. Templum Aesculapius, or Temple of Aesculapius.

h. Templum Jovis, or Temple of Jupiter.

i. Sacellura et Ara, or Chapel and Altar.

k. Gynecium, eft Textrinum, feu Conclave, or Apartments for Matrons and Young Women.

l. Aulicorum Aedes, or Apartments for Courtiers,

m. Porta Aurea, or Golden Gate,

n. Porta Ferrea, or Iron Gate, or Porta Aenea, or Brazen Gate.

N.B. I have explained this Plate not only by the Terms used amongst the Ancients, but likewise by a Translation, such as they would admit of.

View of the Crypto Porticus or

Front towards the Harbour

PLATE VII.

View of the Crypto Porticus, or Front towards the Harbour.

A. Ancient Wall of the Palace.

B. Modern Wall built upon the Ancient Arcade; many of the Arches are likewise filled up with Modern Work.

C. Modern Houses built against the Wall of the Palace;

D. Part of the Harbour.

E. Part of the Town of Spalatro.

PLATE VIII.

Geometrical Elevation of the Crypto Porticus, or South Wall of the Palace; and the Elevation of the same Wall as it now remains.

40

In this Plate I have given the Ancient Wall of the Crypto Porticus in its present State, to shew my Authority for the Restored Elevation. The Center Part over the Door into the Vaulted Story, is now entirely destroyed; which I have supplied, by following the Style of the two End Windows next the Towers, and from the Porticus to the Veftibulum (Vide Plate XXI.) In Imitation of which I have put a Triangular Pediment, as I think it extremely probable the Architect to this Palace would choose to distinguish the Center of so long a Building, and the Vacuity answers precisely to this Decoration.

The Whole of the Arcade and Basement Story of this Front, are built of the beautiful Free-stone from Tragurium, which appears little inferior to Marble. The Columns of the two End Windows are of Granite.

Elevation and Profil of one Arch of the Crypto Porticus

PLATE IX.

41

Elevation and Profile of one Arch of the Crypto Porticus.

A. Elevation of the Arch.

B, Profile of the same.

The Columns which divide the Arches, project one Half of their Diameter, and are of an uncommon Kind; they approach moll to the Doric, both in their Mouldings and Proportions, being exactly Eight Diameters of the Column in Height. No Signs remain of there having been any Enrichments upon the Vase of the Capitals, which, from the Fillet of the Cavetto at Top, to the Collorino, is one Diameter of the Column. The String at the Bottom, which breaks like a Console under each Column runs all along from Tower to Tower. The Dentil Cornice, with two plain Fascias under it, seems to have been kept simple, to correspond with the general State of the Order; and the Whole is far from having a bad Effect.

Elevation of the Lane

Front and Elevation of the...

43

PLATE X.

Geometrical Elevation of the Porta Aenea, or East Wall of the Palace.

 A. Porta Aenea.
 B B. Octagon Towers on each Side of the Gate.
 C. Square Towers of the Palace.

Elevation of the same as it now remains.

 D. Modern Building, where the Ancient Wall is destroyed.
 E. Square Tower, which had been greatly decayed, and afterwards repaired in this Form. Although but little of the Ancient Porta Aenea remains, by which I could form a proper Conjecture of its ancient State, yet I was enabled to make out the Whole from the Remains of the Porta Ferrea on the Well Side of the Palace (see Plate XVII.), which is almost perfectly entire, and seems to be precisely similar to this Gate in those Parts that still remain.

Elevation of the San...

Garden and Elevation of the Pe...

PLATE XI.

47

Geometrical Elevation of the Porta Aurea, or North Wall of the Palace.

Elevation of the same Wall as it now remains.

View of the Porta Aurea

PLATE XII.

View of the Porta Aurea.

A. Gate and Arch now built up by the Spalatrines.
B. Granite Columns supported by Consoles, (see Plates XV, and XVI.)
C. Niches for Statues.
D. Part of one of the Octagon Towers.
E. Windows which give Light to a Nunnery, of which this Gate now forms one of the Walls.

Ground and Chamber of the —

PLATE XIII.

Geometrical Elevation of the Porta Aurea and Octagon Towers.

A. The principal Gate, divided from a Semicircular Opening over it, by a flat Arch of a particular Construction, which remains perfectly entire.

B. Octagon Tower on the East Side of the Gate, shewing the Outside Wall.

C. Octagon Tower on the West Side of the Gate, shewing Part of the Inside Wall, with the Doors from the Ground Story and Gallery above, and the Trusses for carrying the Timbers of the Floor and Roof. This Gate is more ornamented than the other Gates of the Palace, it being the principal Entry to the Emperor's Apartment, and fronting the Porticus of the Vestibulum. The lower Niches on each Side of the Care, as well as the Arch over it, encroach too much upon the superior Order, and do not

50

seem to add to the Beauty of the Building, either by their Form or Situation. It is not my Part to enquire into the Reasons that might induce Diocletian's Architect to make this Disposition, which appears to me much inferior to many other Parts of the Building.

PLATE XIV.

Impost Cornice and Archivolt of the Porta Aurea.

A. Part of the Import: Cornice.
B. Part of the Archivolt.
C. Console and Part of the Cill of the Niches of the Porta Aurea.

Impost Cornice and Archivolt of the Porta Aurea

Console and part of the Cill of the Niches of the Porta Aurea

PLATE XV.

Consoles which support the Columns of the Porta Aurea.

A. Fronts of the Consoles.
B. Profiles of the Consoles.

PLATE XVI.

Import and Archivolt of the Upper Niches of the Porta Aurea.

A, Import.
B. Junction of Part of two Archivolts.
C. One of the Consoles in Perspective.

Plate XVI

Import and Archivolt of the Upper Niches of the Porta Aurea

One of the Consoles in Perspective

PLATE XVII.

View of the Porta Ferrea.

A. The Porta Ferrea, or Iron Gate.

B. One of the Ancient Octagonal Towers.

C. Guard-Room formed of Antique Columns, and other Fragments of Marble taken from the Palace.

D. Court of Justice.

E. The Piazza, or Marketplace of the present Tower

PLATE XVIII.

A. Octagon Tower of the Porta Aurea.
B. The Porta Aurea.
C C. Exterior Wall of the Palace.
D D. Apartments for Courtiers.
E. Porta Aenea.
F. Temple of Jupiter.
G. Peristylium, or Fore Court of the Palace.
H. The Porticus of the Vestibulum.
I. The Vestibulum.
K. Part of the Walls of the Emperor's Apartments.
L. The Crypto Porticus.
M. Square Tower at one End of the Crypto Porticus."
N N. Vaulted Story under the Apartments of the Emperor.

PLATE XIX.

General Section of the Palace from East to West.

A. Octagon Tower of the Porta Aenea.
B. Porta Aenea.

C C C. Exterior Wall of the Crypto Porticus.

D. Inside of the Temple of Jupiter.

E. Vault under the Temple.

F F. Remaining Walls of the Exedrae.

G. Porticus and Vestibulum of the Palace.

H. Temple of Aesfculapius.

I, Vaults under the Temple.

K K. Gates to the Streets of Communication within the Palace.

L. Porta Ferrea.

M. Octagon Tower of the Porta Ferrea.

NNNN. Passages in the Walls of the Gateways which communicate with the Galleries round three Sides of the Palace.

PLATE XX.

View of the Peristylium of the Palace.

A. Front of the Vestibulum.
B. Part of the Spire of the Cathedral Church.
C C. Collonades on each Side of the Peristylium.
D. Part of the Temple of Jupiter.
E. Gothic Sepulchre.

F. Marble Lattice anciently placed between the Columns of the Peristylium, dividing it from the Courts of the Temples.

G G. Two modern Chapels built within the Porticus of the Vestibulum.

H. Sphynx formerly placed within the Temple of Jupiter.

I I. Arches of the Covered Arcades of the Street from the East to the West Gate, now converted into Shops:

In the principal Front of Diocletian's Baths at Rome, published from the Drawings of Palladio by Lord Burlington, there is an Arcade, supported by Columns, with Archivolts from Column to Column, exactly similar to those of the Peristylium of this Palace. As that Part of these Baths have been destroyed since Palladio's Time, I am obliged to quote his Authority, instead of appealing to the Original itself.

Total Extent 52 8.5

Elevation of the Portico to the Vestibulum

PLATE XXI.

Elevation of the Portico to the Vestibulum.

The Corinthian Columns of this Porticus, as well two Center Columns of the Porticus is somewhat as those on both Sides of the Peristylium, are of singular, though we find almost a similar Oriental Granite, and the Entablatures and Capitals of Statuary Marble. The Arch over the two Center Columns of the Porticus is somewhat singular, though we find almost a

similar instance in Mr. Wood's Balbec, Plate VII. This form may be liable to Objection as deviating from the pure simplicity of the Ancients; yet it appears to have been from something of this Kind that Palladio, and other Architects of his Time, have adopted the Modern Venetian Window, which bears a great Resemblance to this Porticus of Diocletian's Palace.

Order of the Portico to the Vestibulum in the Peristylium

PLATE XXII.

View of the Inside of the Vestibulum

PLATE XXIII.

View of the Inside of the Vestibulum.

A. Door from the Portions.
B. Part of the Arch of the Vaulted Story.
C. A Modern Building within the Vestibulum.

The inside of the Vestibulum was built of Brick, and covered over with a hard Cement for receiving an Incrustation of Marble, in the same Manner as the Walls of some of the Apartments in the Baths of this Emperor at Rome; and also of those of Caracalla, where there still remain

64

some Parts finished in that Way. The Dome is also Arched with Bricks, but so much decayed that it is not now possible to discover in what Manner it has been adorned.

The Architraves, Frises, and Cornices are all of White Marble.

PLATE XXIV.

Door of the Vestibulum.

Plate XXV.

PLATE XXV.

Part of the Door of the Vestibulum to a larger Scale.

66

Plan of the Temple of Jupiter

PLATE XXVI.

67

Plan of the Temple of Jupiter.

A. Circular Niches of the Temple.
B. Square Niches.
C. Stairs of the Temple.
D. Door of the Temple.
E. Covered Collonade round the Temple.

Side View of the Temple of Jupiter.

PLATE XXVII.

Side View of the Temple of Jupiter.

A. Pedestal which supports the Columns round the Temple.
B. Columns of Granite as they Sow remain.
C C. Part of the Entablature over the Columns.
D. Wall of the Temple.
E. First Story of the Spire built upon the Landing of the Stairs.

PLATE XXVIII.

View of the Entry to the Temple of Jupiter.

69

A. Door of the Temple, (see Plates XXXI. and XXXII.)
B. Columns that go round the Outside of the Temple.
C. Part of the Entablature and Soffit of the Colonade.
D. Arch which supports the Modern Spire.
E. Gothic Sepulchre.
FF. Ancient Sarcophagi.

Geometrical Elevation of the Temple of Jupiter

PLATE XXIX.

Geometrical Elevation of the Temple of Jupiter.

A. The Stairs.
B. Door of the Temple.
C. Arched Window.

It is extremely probable that the Arched Window to this Temple has been opened since the Time of Diocletian, Light being seldom admitted, (except by the Door) into the Temples of the Ancients. The Construction of the Arch itself appeared to me more modern than the other Parts of the Temple, and Teems greatly to strengthen this Conjecture.

In restoring this Temple, I have placed a Statue over each Column, as I found by the Cramps that remain in the Plinth over the Entablature, that it had been originally decorated in that Manner, though now there are none of the Figures remaining. The Grandeur of the Collonade, which is Areostylos, is in some Degree impaired by the double Pedestal, which goes round the Temple; I should have suspected that Necessity had obliged Diocletian's Architect to use this Method of adding Height to Columns which the Emperor had commissioned from Greece, or perhaps transported from Italy. But upon examining that Building in Palmyra, Plate XLV. which, from the Latin Inscription, is thought to be the Work of Diocletian, I find that the Architect uses a double Pedestal to the Columns there, exactly in the same Manner as in this Temple.

Nor is it less remarkable, that at both Places the Friezes over the Doors are often left out; and in some of the Entablatures the Architraves are so broad, as almost to equal the Height of both frieze and Cornice. Besides these Circumstances there is so great a Similarity in some of the Members and Enrichments of both these Buildings, that it serves, in my Opinion, as an additional Proof of the Justice of Mr. Wood's Hypothesis in ascribing that Temple to our Emperor.

Having made particular Mention of the Roof of this Temple in the Description of the General Plan, I shall only observe, that the Form of a pointed Roof in Temples of this Kind, is uncommon in the ancient Buildings of the Romans, as the Flat Dome seems to have been their more favorite Form: But having found the Roman Stamp upon the Tyles that still cover it, there was no Room left to doubt its Antiquity.

The Stairs to the Temple seem to me very defective, by being so much confined between the large Pedestals on each Side. Had they extended the whole Width of the four Columns in Front, it would undoubtedly have added greatly to the magnificence of the Building. The Walls and Pedestal of the Temple are of Stone from Tragurium; the Columns of Granite; the Capitals and Entablature of White Marble.

Plate XXX.

Exterior Order of the Temple of Jupiter

PLATE XXX.

Exterior Order of the Temple of Jupiter.

72

PLATE XXXI.

Door of the Temple of Jupiter.

Plate XXXII

Part of the Door of the Temple to a Larger Scale

PLATE XXXII.

Part of the Door of the Temple to a larger Scale.

74

The Drafting of this Door, though uncommon, has a bold and pleating Effect. The Ornament upon the Swelling Moulding is of very fine Workmanship. The Modillions in the Cornice are not perpendicular over the Trusses, and offend the Eye greatly. The Angular Modillion, which is to be found in many Parts of this Palace, as well as in other Buildings of the Ancients, seems in this Door to be no additional Ornament.

View of the Inside of the Temple of Jupiter

PLATE XXXIII.

View of the Inside of the Temple of Jupiter.

A. Door of the Temple. B. Window over it.
C. One of the Circular Niches. D. One of the Square Niches.

Geometrical Section of

Temple of Jupiter

PLATE XXXIV.

Geometrical Section of the Temple of Jupiter.

A. Inside of the Dome, shewing the Confirmation of the Brickwork.

B. Entablature of the Second Order, (see Plate XXXVI.)

C. A frieze which goes round the Temple, (see Plates XXXVIII. and XXXIX.)

D. Entablature of the First Order, (see Plate XXXV.)

E. Impost Cornice of the Niches, (see Plate XXXVII.)

F. Door of the Temple.

G. Arched Window over the Door.

H. Section through the Portico to the Temple.

I. Pedestal and Section of the Stairs to the Temple.

K. Section through the Collonade which surrounds the Temple.

The Shafts of the Columns of the First or Corinthian Order within the Temple are of Oriental Granite of one Stone. The Capitals and Bases of the Columns, and all the Entablature, are of Parian Marble. Behind the Corinthian Capitals of the Columns, there are Pilaster Capitals, with a very small Projection, of the same Marble with the Capitals of the Columns: But no Pilaster is carried down, nor no Base shewn, which, however defective it may have been, makes me think that nothing more than the Capitals was ever intended.

The Shafts of the Columns of the second Order, which is Composite, are alternately of Verde Antique, or Ancient Green Marble, and Porphyry, of one Piece. The Capitals and Entablature are also of Parian Marble. Behind each Column in the Second Order is a Pilaster, which projects One Fourth of its Diameter. The Shafts of these Pilasters are of the same Stone as the Walls of the Temple, and worked solid with the Wall; but the Capitals are of the same Marble with that of the Columns. It is very remarkable that this Order had no Bases, either to the Columns or Pilasters, like the Grecian Doric; and the Height of the Column and Capital does not exceed Seven Diameters, which is three Diameters less than is allowed to this Order in most of the other Works of the Ancients.

Plate XXXV

PLATE XXXV.

First Interior Order of the Temple of Jupiter.

Plate XXXVI

Second · Interior Order of the · Temple of Jupiter

PLATE XXXVI.

Second Interior Order of the Temple of Jupiter.

80

Plate XXXVII

Outside Entablature at Top of the Temple of Jupiter

Scale of Feet

Import and Archivolt of the Interior Niches

PLATE XXXVII.

A. Outside Entablature at the Top of the Temple of Jupiter.
B. Import and Archivolt of the Interior Niches.

81

PLATE XXXVIII.

Bas Relief which forms a Frieze in the Inside of the Temple of Jupiter.

82

PLATE XXXIX.

Other Bas Reliefs, being Part of the same Frieze.

83

Plate XL.

Scale of Feet

Plan of the Temple of Æsculapius

PLATE XL.

84

Plan of the Temple of Aesculapius.

A. The Body of the Cell of the Temple.
B. The Door.
C. The Portico.
D. The Stairs partly sunk under Ground.

PLATE XLI.

View of the Temple of Aesculapius.

A. The Back Wall of the Pediment.

B. Architrave that went round the Inside of the Portico,

C. Door of the Temple, (see Plate XLVI.)

D. Large Blocks of Stone, forming the Dado of the Pedestal that supports the Temple.

E. A Marble Urn, the particular Sculptures on which are delineated, Plate LI.

F. Sarcophagus placed by the Door of the Temple.

G. Modern Buildings.

Plate XLII.

Another View of the Temple of Aesculapius.

A. Part of the Stairs leading to the Temple.

B. The other side of the Marble Urn.
C. Modern Buildings.

Lateral Elevation of the Temple of Aesculapius

PLATE XLIII.

Lateral Elevation of the Temple of Aesculapius.

The Walls of this Temple are built of Freestone, and of very fine Workmanship: The Frieze is very elegant, of which I have given the exact Representation, Plate L.

The Roof is finished like an Arch on the Outside, as well as within; but the Pediment at the West End of the Temple, which still remains entire, finishes in a Triangular Form, which was my Authority for finishing the East End, where the Portico was, in the same Manner, though that is now entirely destroyed, as is shewn by the preceding Views.

Section of the Temple of Aesculapius.

PLATE XLIV.

Section of the Temple of Aesculapius.

I was enabled to fix pretty nearly the Distance betwixt the Pilaster and Column of the Portico, both in this Section and in the last Plate, by observing the Vacuity left by one of the Plinths of the Columns which was removed before I went to Spalatro. I for this herein have marked that Column of a darker Colour in the Plan, to show where the Plinth flood, the Center of which Space I have made the Center of the column.

The Whole of the Inside of this Temple is perfectly entire, and of very good Workmanship.

PLATE XLV.

Door of the Temple of Aesculapius.

90

Plate XLVI

Part of the Door of the Temple to a Larger Scale

A

Part of the Soffit of the Cornice

B

Scale of Feet

PLATE XLVI.

91

A. Part of the Door of the Temple to a larger Scale.

If we abstract from the Defect of the angular Modillions in this Door, some of the other Parts of it are very fine. It may indeed be objected with Reason, that it is too much ornamented for an Outside Door; yet we have many Examples in Palmyra and Balbec, of Outside Doors very much loaded with Ornament. The particular Enrichments of this Door are so finely executed, that they afforded me the highest Satisfaction, and by Means of the projecting Portico, the smallest Parts have remained unhurt to this Day.

B. Part of the Soffit of the Cornice.

Plate XLVII.

Exterior Order of the Temple of Aesculapius

PLATE XLVII.

Exterior Order of the Temple of Aesculapius.

93

The Pilaster Capital of this Temple, and indeed ail the Capitals through-out this Palace, are raffled more in the Grecian than the Roman Style, which I have been very careful to imitate. It is more than probable, that Diocletian, who had been so often in that Country, brought his Artificers from Greece to Spalatro, with an Intention to vary the Execution of his Orders of Architecture in this Palace, from those he had executed at his Baths at Rome, which are extremely different both in their Formation and Execution.

Plate XLVIII

Interior Frize and Cornice of the Temple of Aesculapius

Soffit of the above Frize and Cornice

PLATE XLVIII.

A. Interior Frieze and Cornice of the Temple of Aesculapius.
B. Soffit of the above Frieze and Cornice.

The Internal Angular Modillion in this Cornice is very remarkable: I do not remember to have met with any other Instance of it in the Works of the Ancients.

Plate XLIX

Pannels of the Arched Ciling of the Temple of Æsculapius

Capital and Pilaster in the Angle of the Peristylium

PLATE XLIX.

A: Pannels of the Arched Ceiling of the Temple of Aesculapius.

B. Profile of the Mouldings.

C. Capital and Pilaster in the Angle of the Peristylium.

Exterior Frieze of the Temple of Aesculapius

Bas Reliefs of an Urn near the Temple of Aesculapius

PLATE L.

Exterior Frieze of the Temple of Aesculapius.

PLATE LI.

Bas-Relief of an Urn near the Temple of Aesculapius.

97

Plate LII.

Fragment of the Architrave of a Door to the Crypto Porticus.

Enriched Mouldings round the Octagon Towers.

PLATE LII.

Fragment of the Architrave of a Door to the Crypto Porticus.

Enriched Mouldings round the Octagon Towers.

Fragment of a Bas Relief at Spalatro.

PLATE LIII.

Fragment of a Bas Relief at Spalatro.

It is Pity that this Bas Relief was so much destroyed when I saw it, as that Part which remains, representing some Bacchanalian Ceremony, is of exquisite Sculpture.

Plate LIV

Bas Relief in the House of Count Jeremiah at Spalatro

Plate LV

View of a Sphinx which was anciently in the Temple of Jupiter

PLATE LIV.

Bas Relief in the House of Count Jeremiah, at Spalatro.

PLATE LV.

View of a Sphynx, which was anciently in the Temple of Jupiter.

100

Plate LVI

Another View of the Same Sphynx

PLATE LVI.

Another View of the same Sphynx.

PLATE LVII.

Bas Relief in the Church of St. Felix, at Spalatro.

102

Bas Relief representing a Combat with the Centaurs

PLATE LVIII.

Bas Relief, representing a Combat with the Centaurs.

Bas Relief found incrusted in the Spire of the Cathedral Church

PLATE LIX.

Bas Relief found incrusted in the Spire of the Cathedral Church.

PLATE LX.

A. View of a Sphinx, with Hieroglyphics.

C. Another View of the same Sphinx.

B. Front View of the same Sphinx.

View of the Aqueduct which conveyed Water from Palermo to the Palace

PLATE LXI.

View of the Aqueduct which conveyed Water from Salona to the Palace.

This Aqueduct is vulgarly supposed to have been a Highway leading from Salona to Spalatro: But besides the Remains of the Conduit for Water, which is yet observable in many Places, it is too narrow ever to have served for any other Purpose than that of an Aqueduct, as it is not above Eight Feet wide over the Walls. The Nature of the Soil itself was sufficient to convince me of the Absurdity of the common Hypothecs, as the Aqueduct is built either on a hard Rock, or firm Gravel, which rendered any artificial Highway entirely useless between Salona and the Palace.

[1] Vischer, in his Architecture Historique, mentions this Aqueduct as conveying Water from the River Jader, which has its Source in the Mountains two Miles above Salona. In this I think he is right; but cannot agree with his Supposition of there having been a high Road over it; which he seems to have borrowed without Examination, from the common Tradition prevalent among the Spalatrines.

[1] L'Architecture Historique, L. 2. Tab. 10 and 11.

Milton Keynes UK
Ingram Content Group UK Ltd.
UKHW040153130824
446875UK00005B/25

9 781789 873917